Pinta

Marchena

Genovesa

— — — 0°

Santiago

Bartolomé

Seymour
Baltra

Rábida

Pinzón

s. Fe

Santa Cruz

San Cristóbal

Española

Floreana

Galápagos Sketchbook

David Pollock

"Cachalote" at anchor off
St. Cristobal Island - early
morning

FRUTA

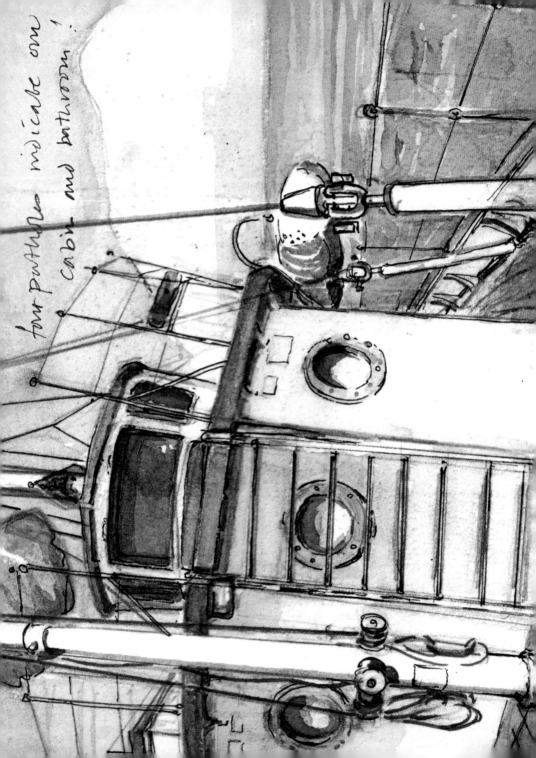

four portholes indicate on
cabin and bathroom !

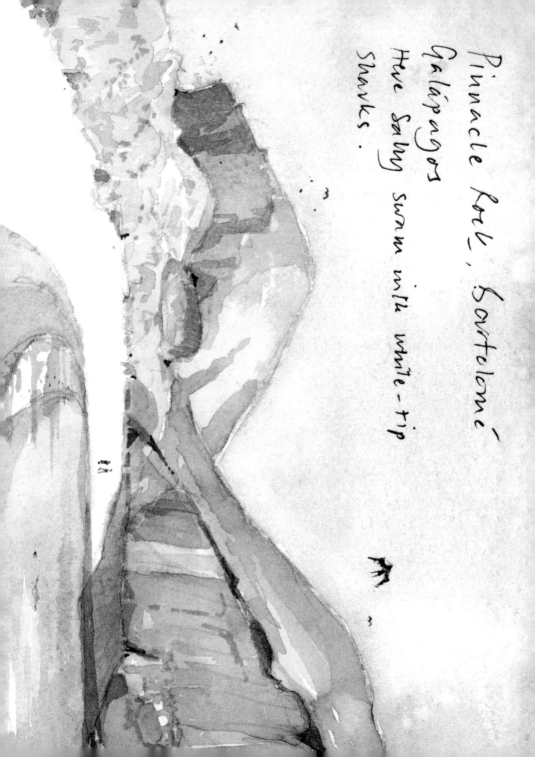

Pinnacle Rock, Bartolome
Galápagos
Here Sally swam with white-tip
Sharks.

Extra Customers
at the fish
market,
Puerto Ayora,
Santa Cruz
Island

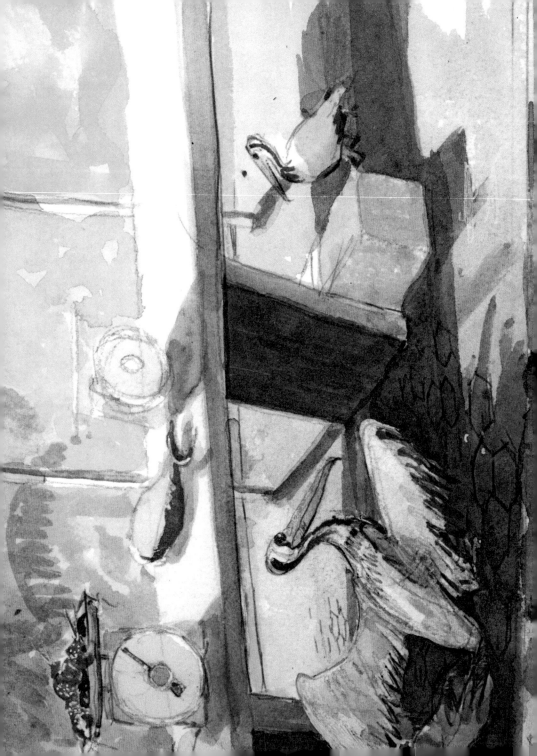

Land iguana on lava seen at
the Darwin Research station
and drawn on the 'Cachalote'.

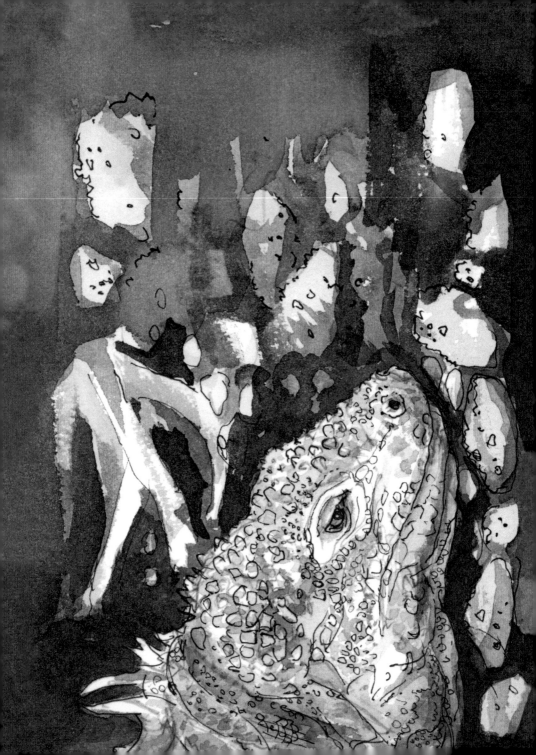

Brown Pelicans
on "Lolita" freight-boat
roof — Puerto·Villamil
Is. Isabela, Galápagos

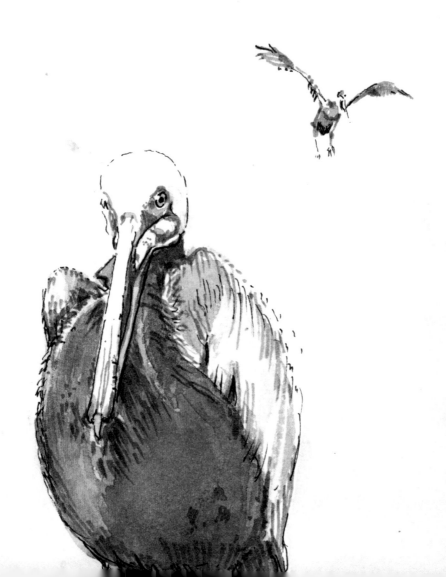

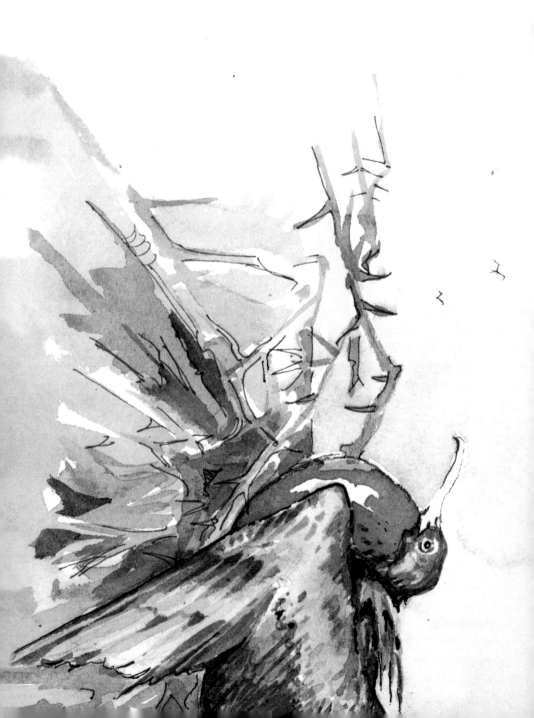

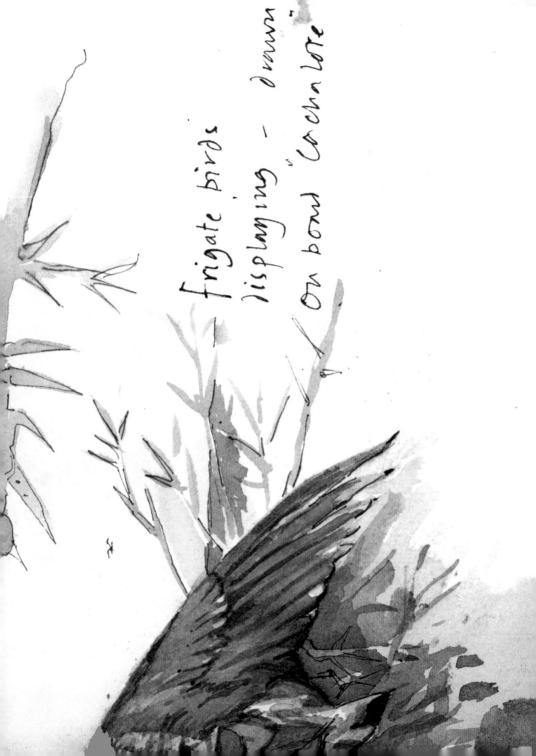

Frigate birds
displaying – dawn
On board "Cochalote"

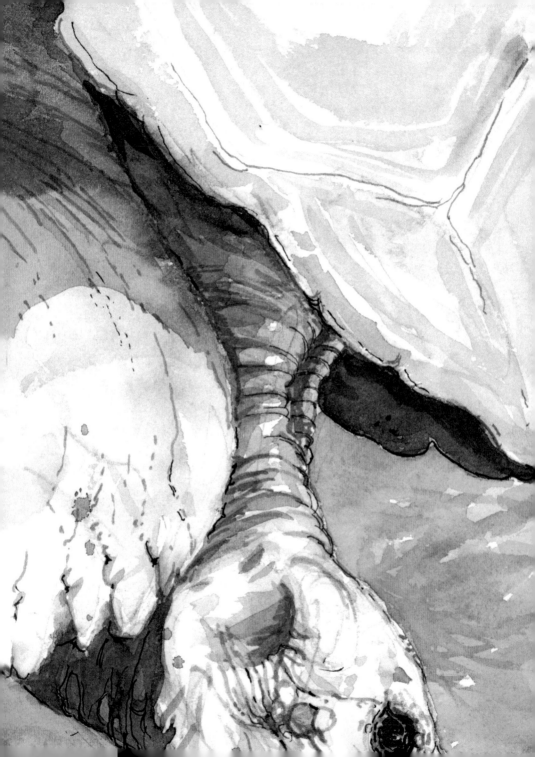

Galapagos Giant Land Tortoise

Lifespan: up to 250 yrs
Weight: up to c. 500 kg
Each island — and each
volcano on Isabela —
had distinct forms

This one photographed and
drawn in the highlands
of Is. Santa Cruz.

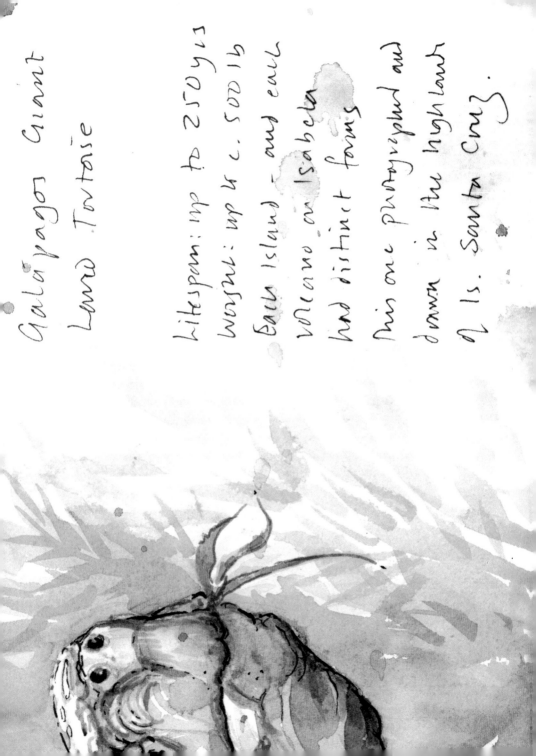

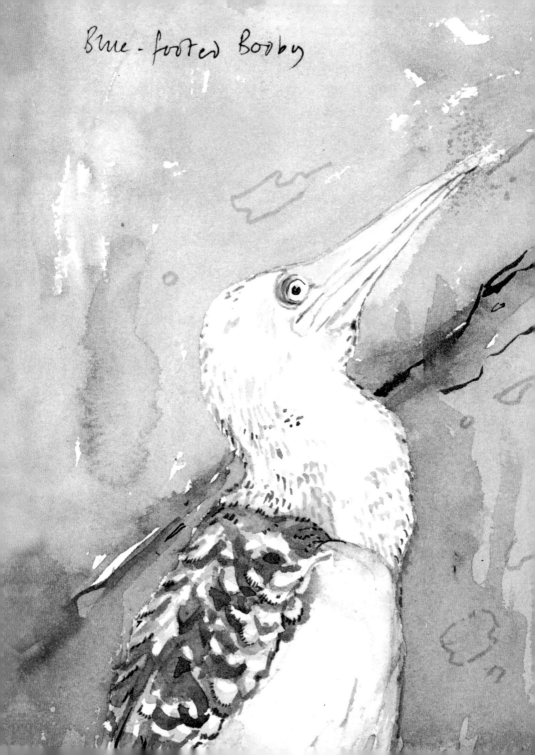

Blue-footed Booby

Yellow-crowned Heron (Night Heron)
at James Bay, Isl. Santiago
Galapagos - early morning

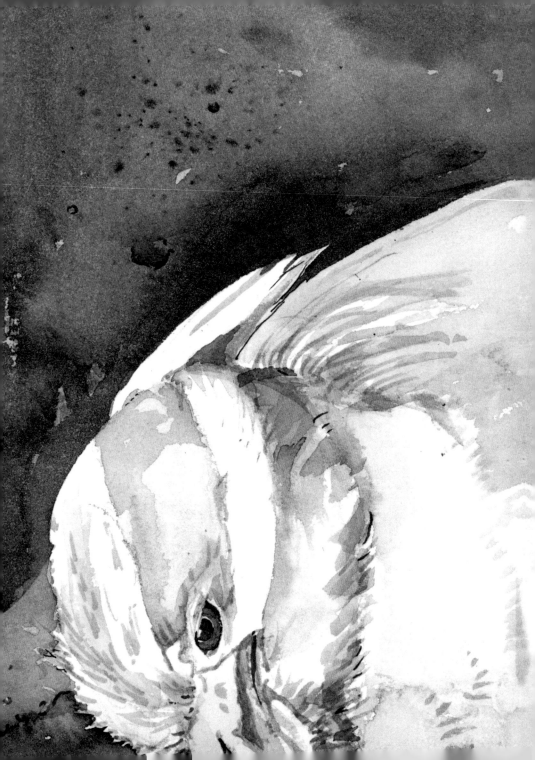

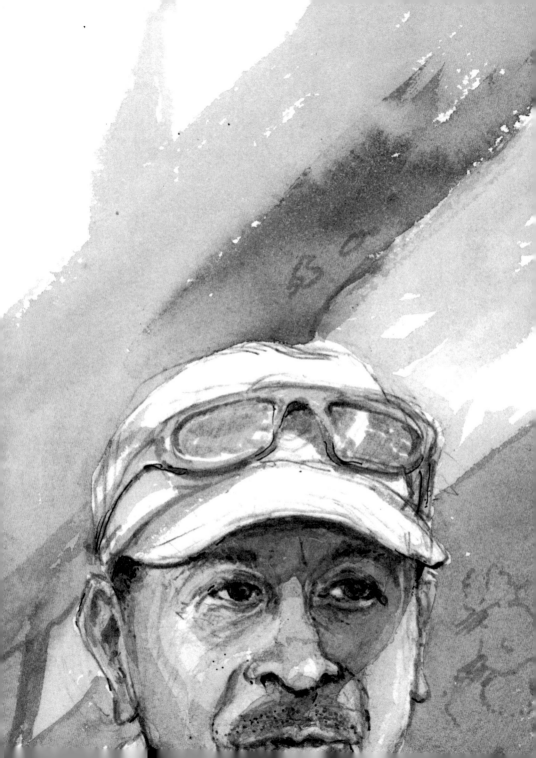

Sv. Juan Tapia,
Galápagos Guide
telling the story of the Wittners
drawn aboard the "Cachalote"

"Cachalote"

with Sally Lightfoot crabs,

marine iguana and a lava cliff

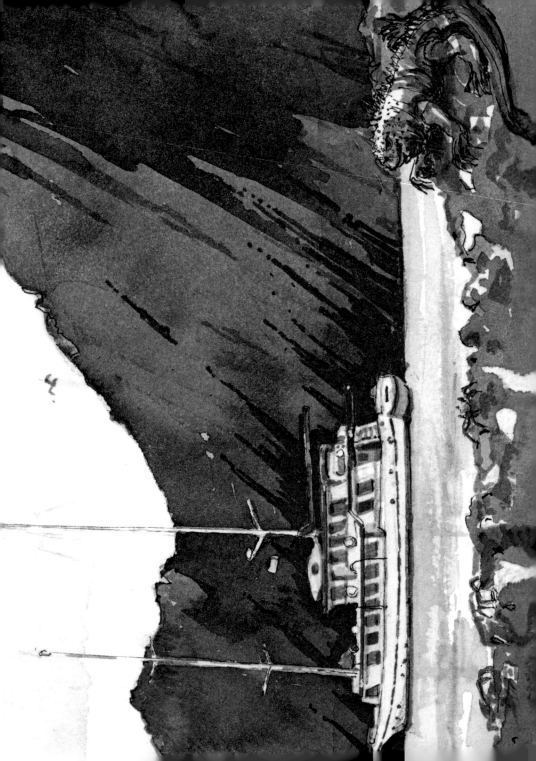

Jinn running the big near Kuihen Rock

(Lea Bermido)

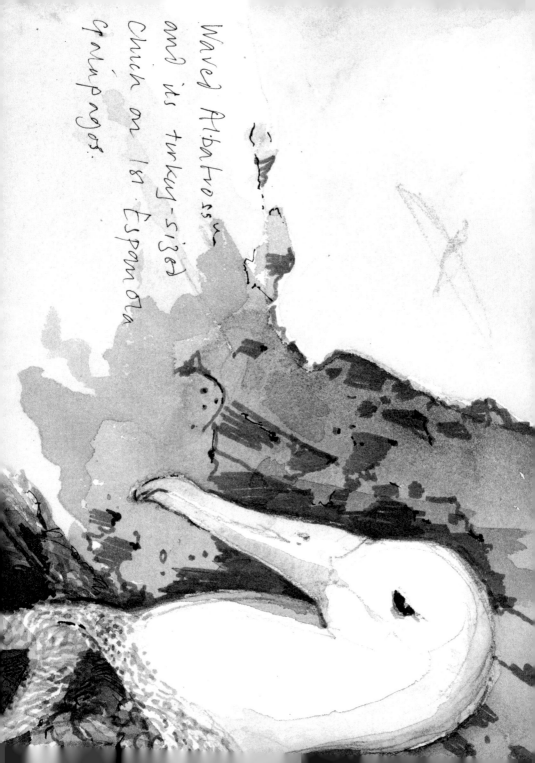

Waved Albatross
and its turkey-sized
chick on Isla Española
Galápagos.

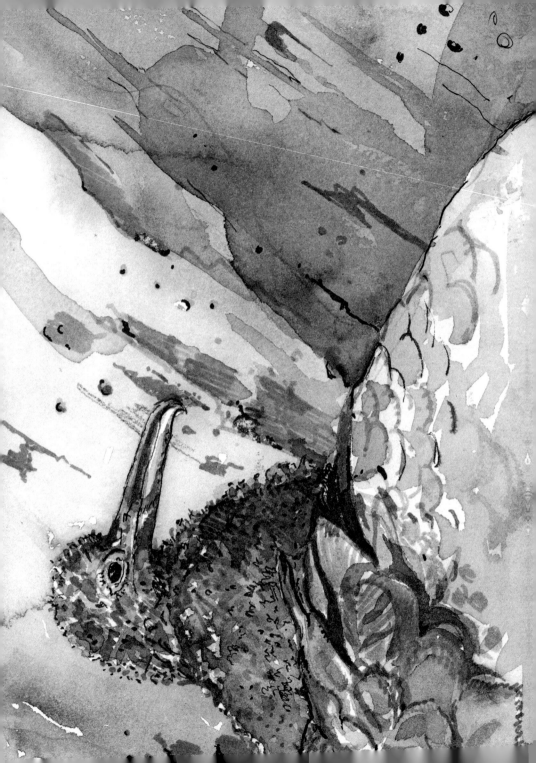

Flustered Juvenile
Frigate Bird

"The Condor of the Oceans"
according to Charles Darwin —
The largest wingspan — area body
weight ratio of any
bird in the world.

As seen, North Seymour
Island.

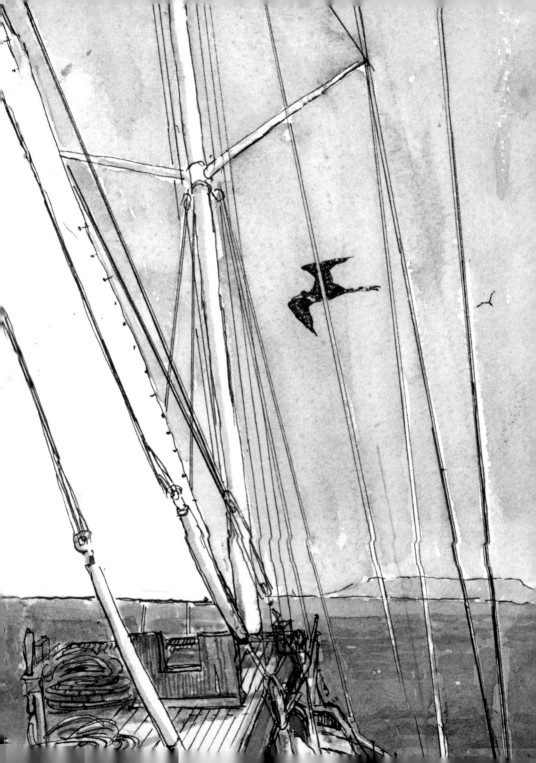

"Cachalote"
off the coast
of Is. Isabela
— Sailing under
a single staysail
only. mid-day

Frigate birds in
company.

Booby Chick
Española Island
Galápagos

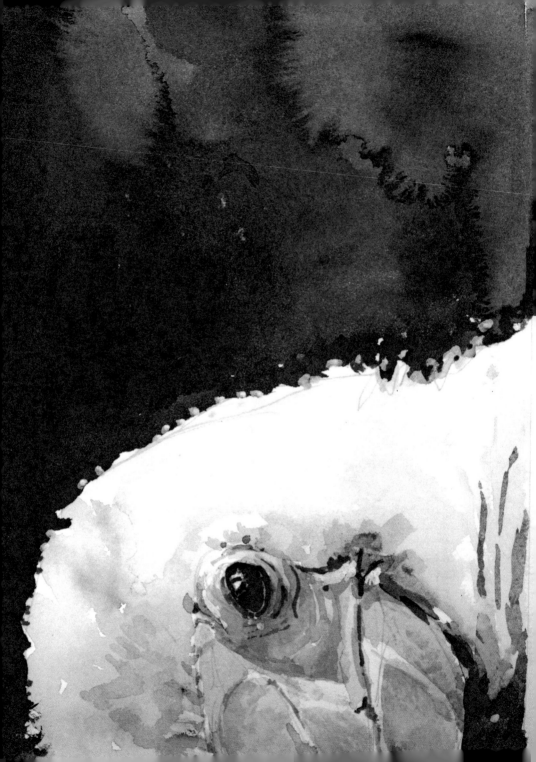

Sally Light foot Crab

(Abuete Negra ;
Grapsus grapsus)

Marine Iguanas in the surf —
Coloration changes / brightens with age
m) location —
brightest — A.K.A. Animals from Espeñola are the
"imps of darkness" according to
Charles Darwin.
"Christmas Iguanas"

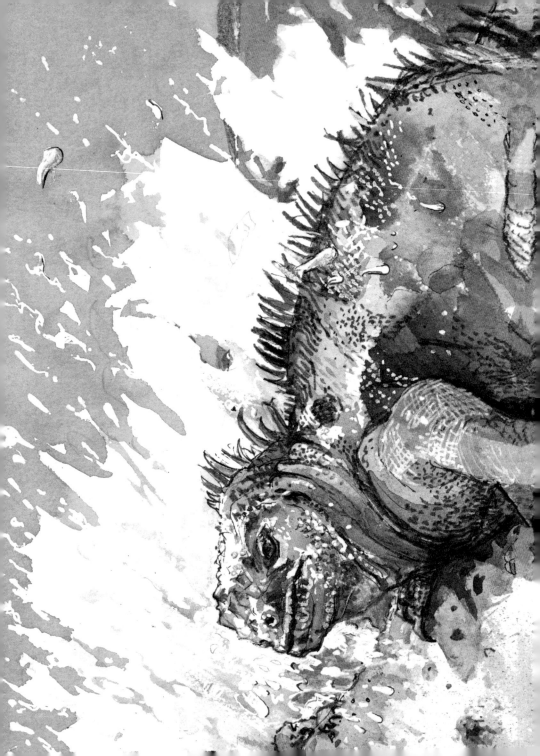

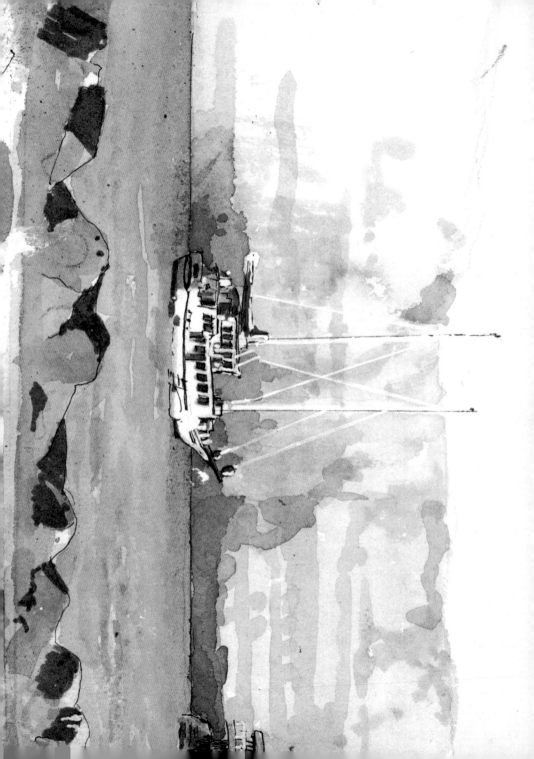

"Cachalote", a tow boat
and a Blue-footed Booby
off Santa Cruz

Galapagos
Short-eared Owl –
a night-time hunter but
will also venture out in daylight
known to "stalk" petrels and
other prey. – A silent flier with
... span of up to 1 m.

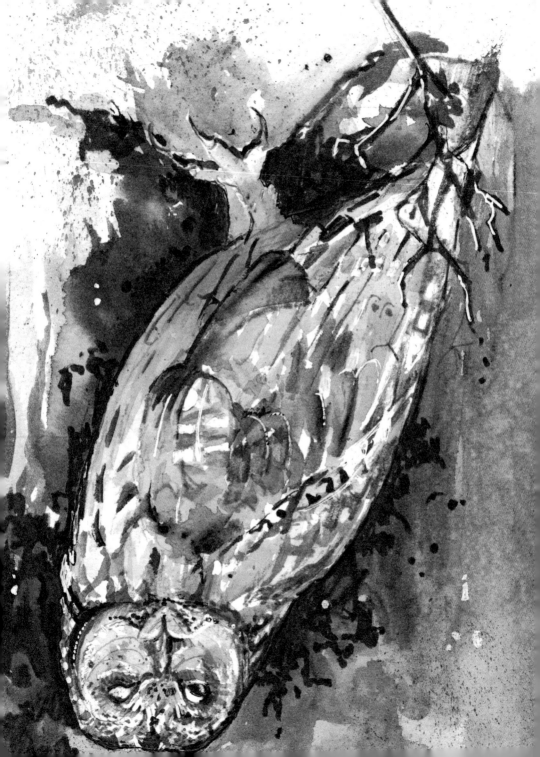

Imaginary Encounter with a large, Pinta-type saddleback tortoise.

Generally considered Extinct following the death of "Lonesome George" at the C.D. Research Stn in 2012. In some

your however, 17 first generation hybrids found in Isabela could any of their parent Pintas still survive?

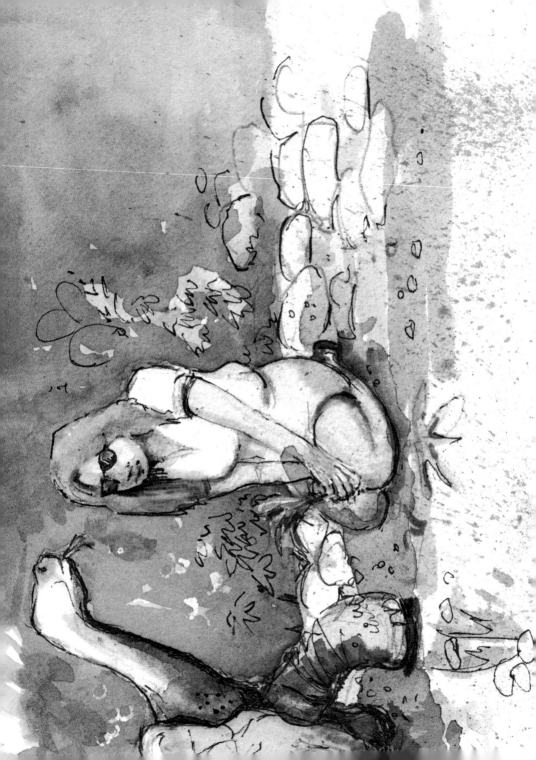

Sealions +
Sally Lightfoot
Crabs

- or a blustery
afternoon
swimming!

Little (?) Finch on
Red Lava Pebbles —

2 of the 13 species
Still evolving; th[e]
especial[ly]
bill sh[...]
i[...]

Charle[s]
Darw[in]
think[s]
on evo[...]
an[d] wen[t]
the "Orig[in]
Species

Darwin's Finches,
variations

Unidentified finch
with strong seed-
cracking bill

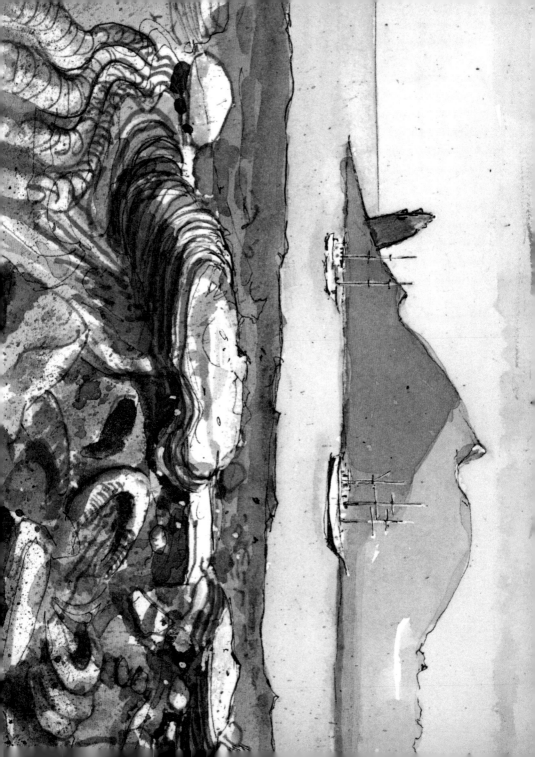

Pahoehoe lava with
Bartolomé and Pinnacle
Rock beyond - Cachalote
and an elegant square-
Rigger riding at
anchor.

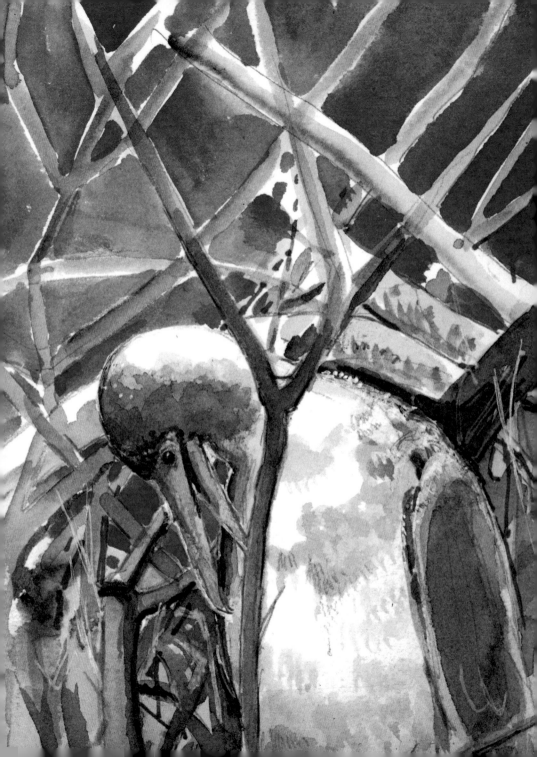

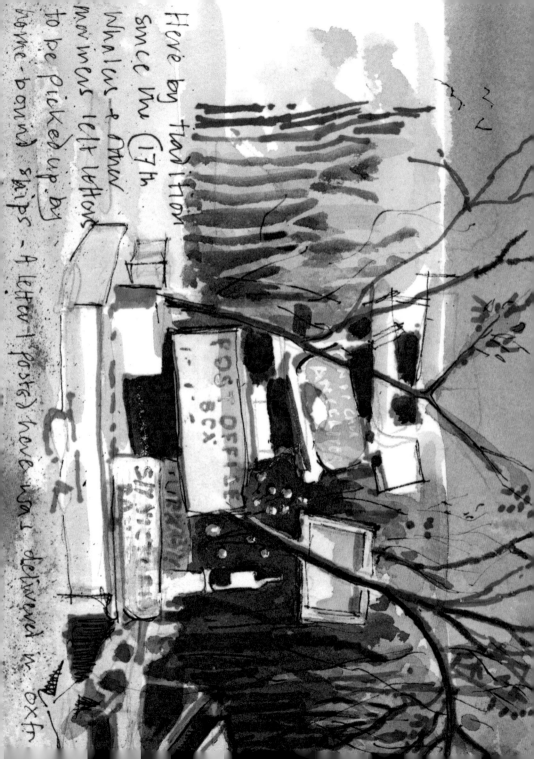

Here by tradition
since the (17th
Whalers + other
mariners left letters
to be picked up by
home-bound ships - A letter (posted) here was delivered in Oxfd

POST OFFICE
BCX

The Post-
Office

Barrel on
Floreana

HORIZON

4 weeks later...

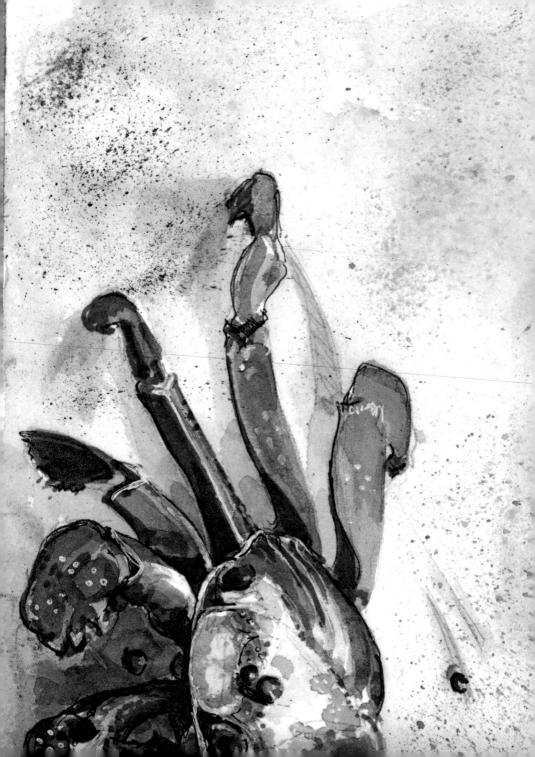

Sally Lightfoot Crab

(Grapsus Grapsus)

Mobile Jewels A
Gallápagos beaches

Two drawings of the
before + during
take-off !

same Brown Pelican –
(Pelecanus occidentalis)

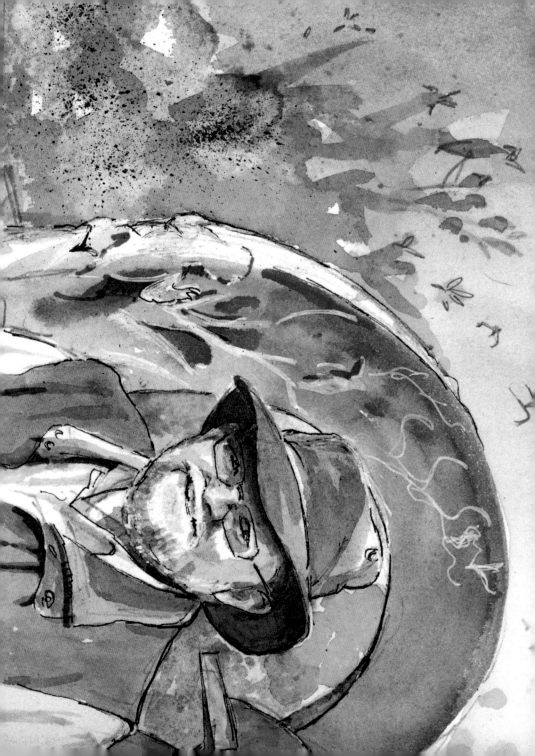

Tim Bruce at

the Charles Darwin

Research Station,

Puerto Ayora,

Islas Galápagos –

Rather an emaciated

portrait bust ! CD . .

Cachalote
and Galapagos Penguins
at Fernandina

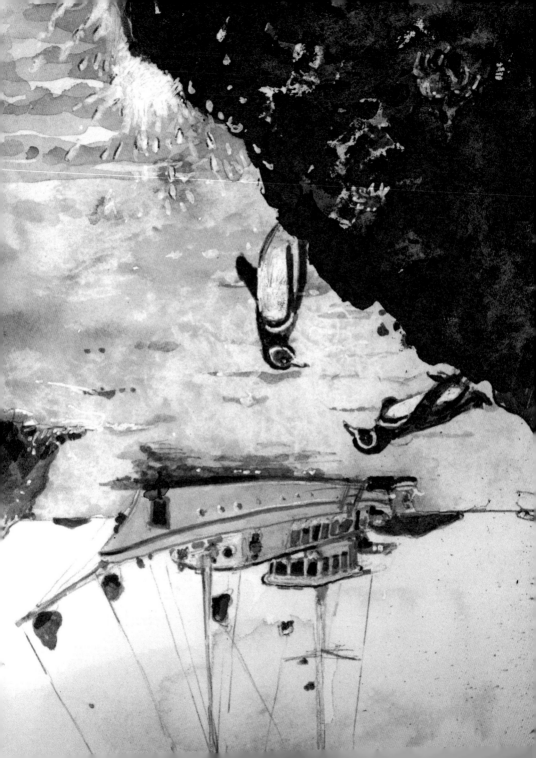

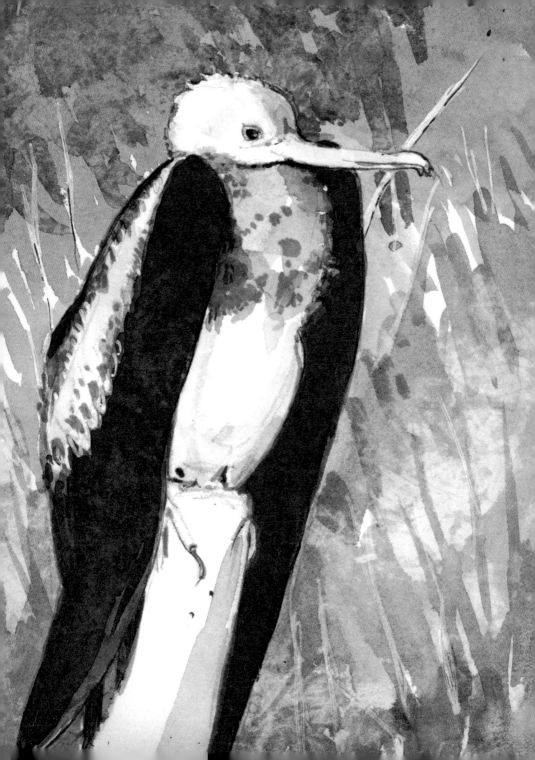

Juvenile
Frigate Bird

Perching near
ground level

Like the Galleri Ballet for birds!
Exquisite.

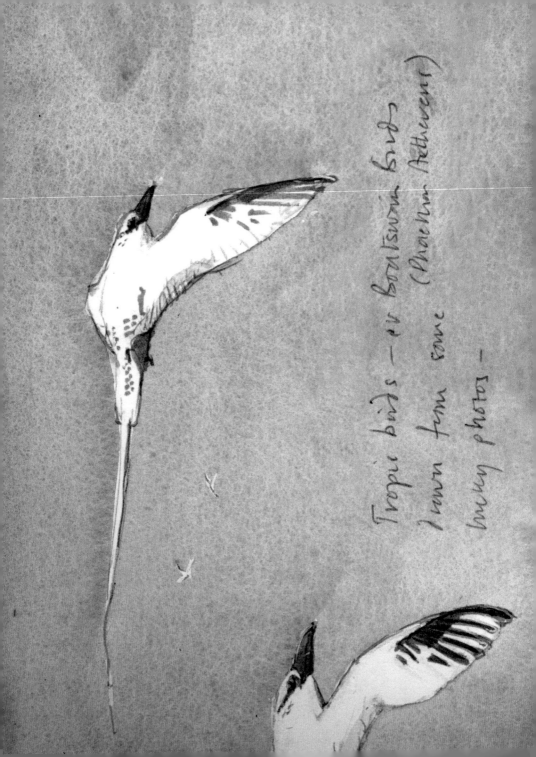

Tropic birds — or Boatswain birds
I knew from some (Phaeton Aethereus)
many photos —

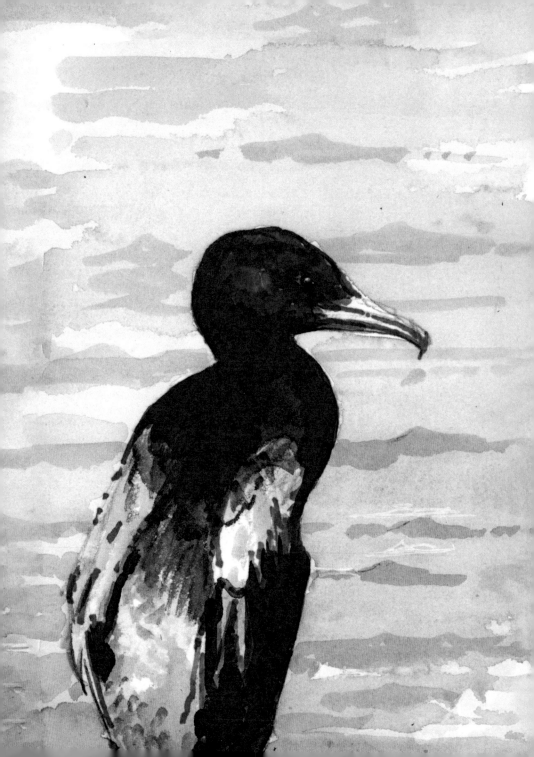

(2004 –
C.D. Research Station
reported only 1500
individuals.)

Flightless Cormorant

(Phalacrocorax harrisi)
endemic to the Galápagos –
Fernandina and (as here)
N.W. Isabela
As name suggests, vestigial wings
do not support flight.

Portrait of
an Irish ...
Name Mhic ...

Nazca Booby -
Largest ? B booby
Span - As seen on
Floreana

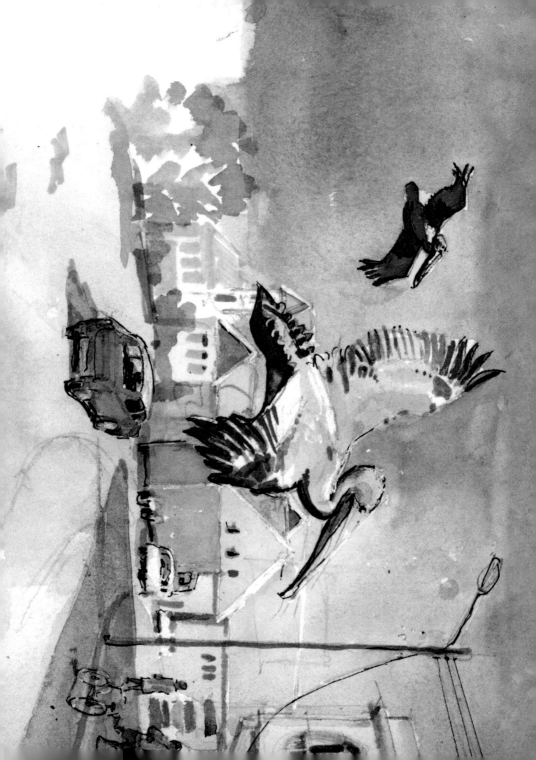

Pelicans in
Puerto Ayora – and
the Rincón – Happy hour
hangout of the Cachalote
contingent!

EL RINCÓN DEL ALMA

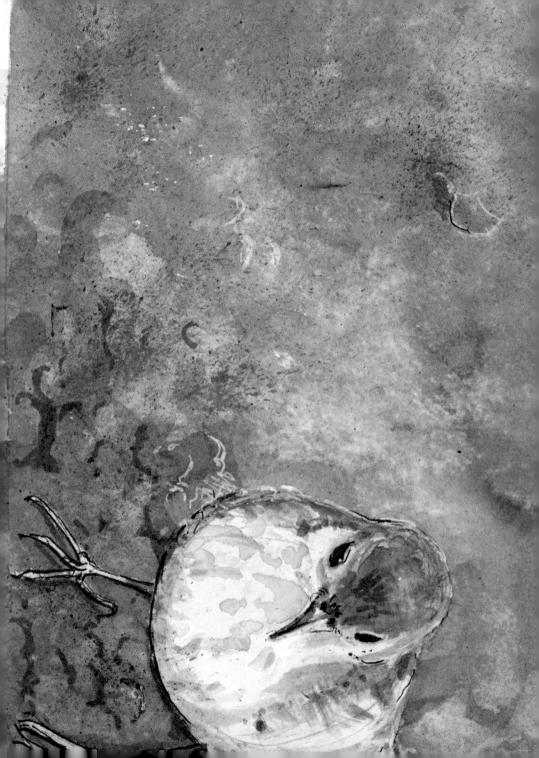

Yellow warbler.

(Dendroica petechia) *

Shows small variations
between the individual
[clinal] populations, altogether ---

* Recently renamed!
Setophaga petechia

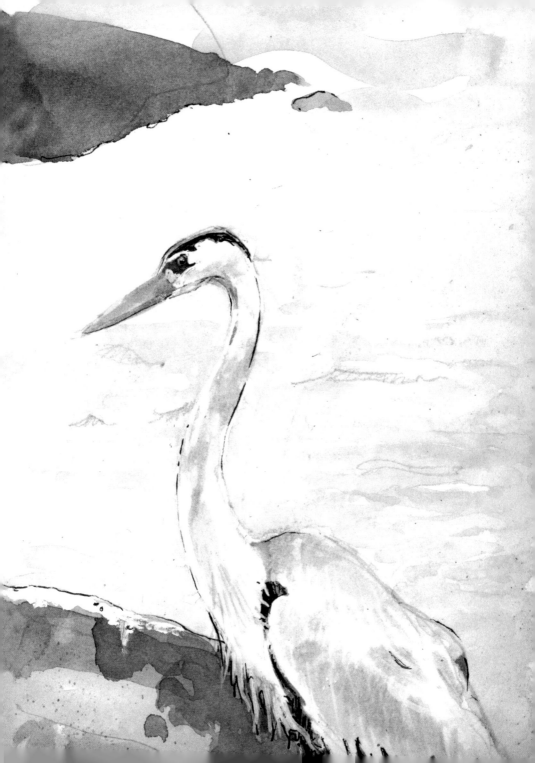

Great Blue Heron
(Ardea Herodias)
as seen on Fernandina –
devourer of marine
iguana hatchlings

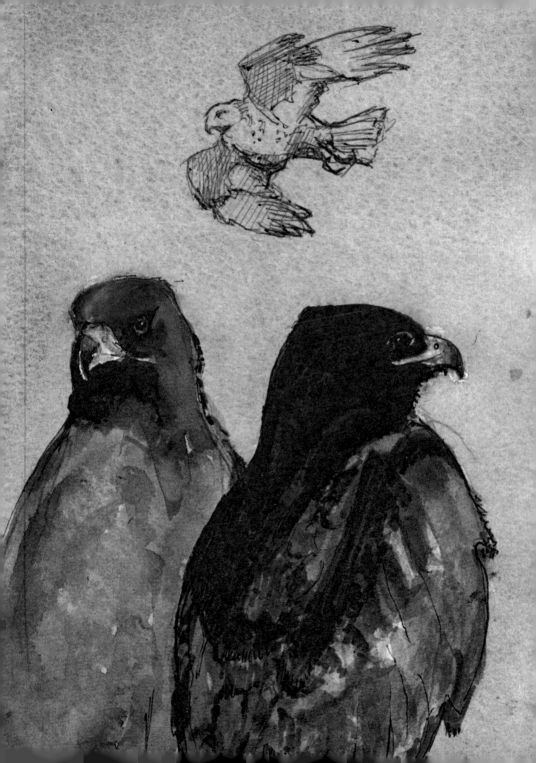

Galápagos Hawk.
-The top predator in
the Islands
As seen on
Isabela

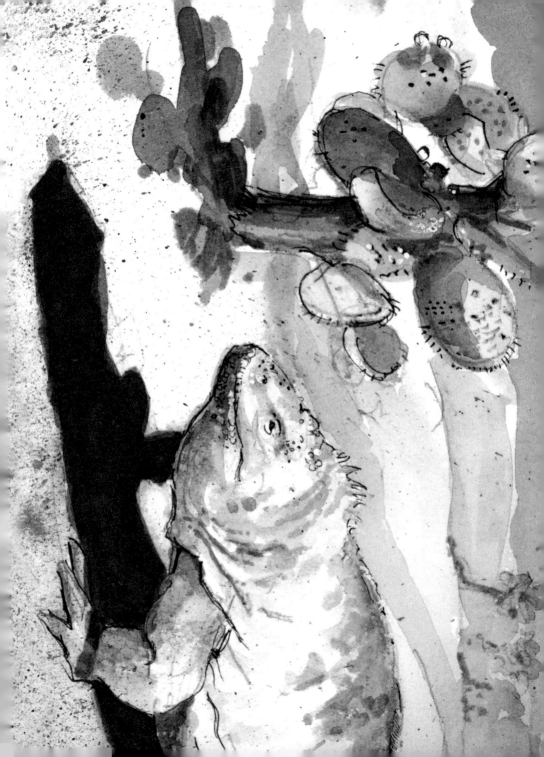

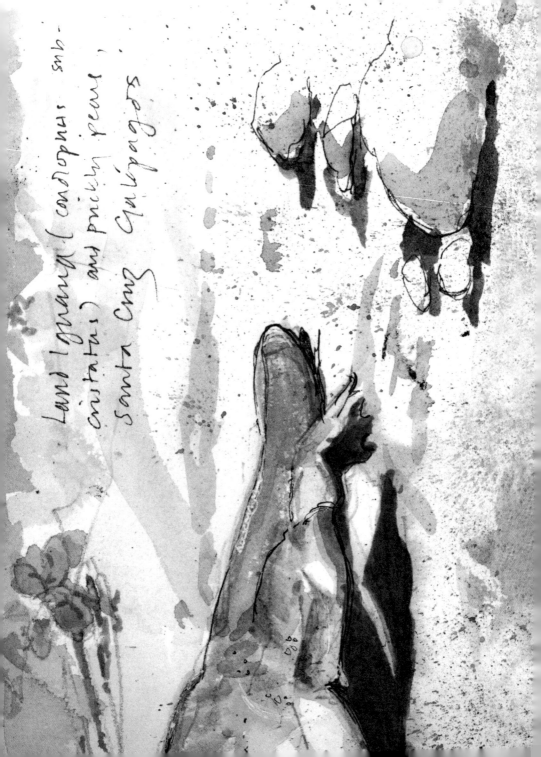

Land Iguana (conolophus sub-
cristatus) and prickly pears,
Santa Cruz Galápagos

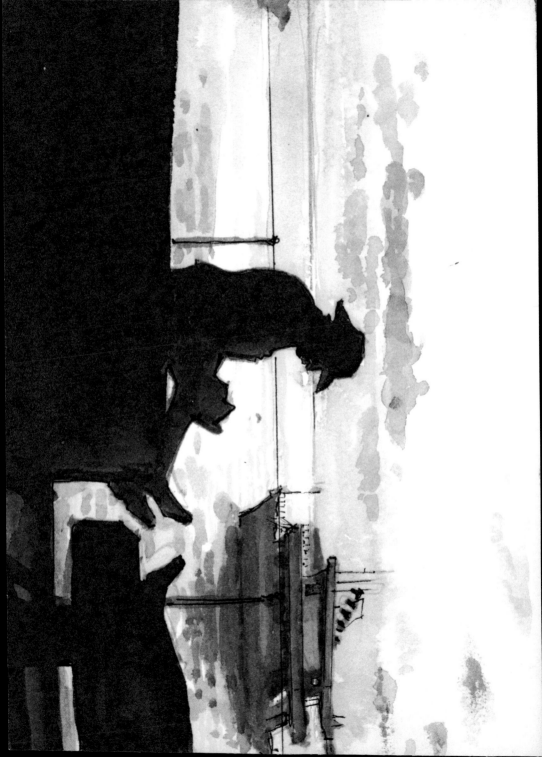

Sunset
silhouettes,
on board Cachalote
At Espinosa.

Afterword

The Galápagos Islands have an almost mythic status: a volcanic paradise with fauna unafraid of human visitors, and unspoiled flora.

Species there still show the environment-dependent variations that, almost two hundred years ago, led Charles Darwin to formulate the theory of natural selection, laying out the path to modern scientific thinking about the development of life on our planet.

Memorable wildlife encounters there are certain: the sea lion cub that 'trained' me to pick up fish scraps from the seabed; the giant fluffy albatross chicks being fed by their parents, a bare metre from me, for example.

The threats to the Galápagos, however, have never been greater. Global warming in general threatens ecosystems in the islands; the El Niño phenomenon, increasingly fierce and frequent, has warmed the waters of essential cold currents; industrial fishing is getting closer;

and although action is being taken to reduce the damage caused by visitors and introduced species, we cannot be complacent. The magic is seriously threatened by those who come to enjoy it.

In the front line of efforts to defend the Galápagos is Galápagos Conservation Trust, a London-based organisation which will benefit from any profits from this book.

The Galápagos have inspired millions of words and thousands of pictures. Why then this facsimile of my sketchbook?

I hope it will provide a different take on the Galápagos experience. It includes pictures not only of wildlife but also of places and people that caught my imagination; and I hope it will both encourage responsible amateur naturalists to make the journey themselves, and stir the memories of old Galápagos hands.

My drawings are from life or, where necessary, from

my own photographs and, in one or two cases, other sources. I made them to help me understand the subjects better. Serious naturalists and ornithologists will, I am sure, spot errors and inaccuracies. They are entirely my responsibility. This little book is simply my own impression of an extraordinary place and I hope it will inspire readers to love and respect these islands and to support Galápagos Conservation Trust.

David Pollock
Oxford, Autumn 2023

Appreciation
by Mick Rooney RA

In the 1970's the Galápagos Islands, to those who had heard of them through the works of Charles Darwin, were specks of forgotten time on which mythical creatures roamed.

Then by boat and aeroplane well-off tourist/adventurers journeyed there to have a look.

And now in the twenty-first century David Pollock has been to have a look. And he has given it a good look.

He has produced a richly textured record of his visit and reconnected with the noble art of the topographical illustrator—the type of draughtsman and draughtsmanship that accompanied Darwin on his expeditions.

It is so refreshing to look at the graphic image. Photography in itself is often unforgiving and unselective and its 'reality' can get in the way of the 'natural selection' of place and subject, and of sifting out what is not essential.

David Pollock's book does the essential. His intimate personal choice of what he has seen and done is a journal-capsule in time. Within the pages birds and mammals and other species abound and the human element appears in hats and gear seemingly much at odds with this ancient, primal paradise.

The naming of the creatures elicits a kind of poetry: magnificent frigatebirds, blue-footed boobies, marine iguanas and giant tortoises. They read as characters from a children's story set on an enchanted island.

Pollock's watercolours spread his clear personal vision throughout the book and the well-honed images somehow draw attention to the fragility of even the remotest places on this planet.

Autumn 2023

*Notes on fauna
and other matters*

*(in order
of appearance)*

GALÁPAGOS SEA LION *Zalophus wollebaeki*
Endangered species breeding only in the Galápagos and Isla
de la Plata. The smallest sea lion species, the animals are still
numerous throughout the archipelago. Length 1.5–2.5 m,
weight 50–250 kg.

GALÁPAGOS BROWN PELICAN *Pelecanus occidentalis*
Dives for fish, predates fledglings and small reptiles. Breeds
year-round in the archipelago. Wingspan up to 2.28 m, weight
up to 5 kg.

GALÁPAGOS LAND IGUANA *Conolophus subcristatus*
Primarily herbivore lizard, length 1–1.5 m, weight up to c. 11 kg.
Still common in the archipelago but populations have declined
particularly because of introduced cats, pigs etc; classified
vulnerable.

FRIGATEBIRD

GREAT FRIGATEBIRD: *Fregata minor*
MAGNIFICENT FRIGATEBIRD: *Fregata magnificens*
These two species are found side by side in the Galápagos,
distinguishable with difficulty. The Great has a green sheen to its
plumage, the Magnificent a purplish tint in the right light. Males

have inflatable red gular sac, females have white breast and belly. The Magnificent is slightly the larger but both have wingspans well over 1 m. Diet: fish, squid, crabs etc and occasional fledglings. Weight up to 1.6 kg.

GALÁPAGOS GIANT TORTOISE *Chelonoidis niger*

Largest living species of tortoise, found on seven Galápagos islands. Twelve extant subspecies: differences of shell shape and neck length dependent on local environment and available vegetation for diet. This made them important in the development of Darwin's theories. Length up to c. 1.5 m, weight up to c. 230 kg. Classified vulnerable to critically endangered.

BLUE-FOOTED BOOBY *Sula nebouxii*

One half of all breeding pairs of this diving seabird nest in the archipelago. Diet primarily fish. Wingspan up to 1.5 m, weight up to 1.5 kg. Characteristic blue feet are displayed in mating rituals.

YELLOW-CROWNED HERON *Nyctanassa violacea*

Small heron species; found in intertidal zones and mangrove swamps throughout archipelago. Wingspan up to 1.1 m, weight up to 850 g.

HUMAN BEING *Homo sapiens*

In 1972 there were 3,488 people living in the Galápagos. By 2022 this figure had risen to some 30,000. Typically, in addition, about a quarter of a million people visit the islands each year. The stress on the natural environment is considerable. Active conservation measures are essential and need all our support.

SALLY LIGHTFOOT CRAB *Grapsus grapsus*

Agile scavenger characteristic of most Galápagos beaches. 8–12 cm.

MARINE IGUANA *Amblyrhynchus cristatus*

Found only on the Galápagos; herbivore, eating algæ etc; 60–100 cm in length, and up to c. 1.5 kg in weight. Unique amongst lizards because of its habit of foraging at sea. First-class swimmer, capable of submerging for 45 minutes. Colour, details of body shape etc specific to the different islands. Mutually fertile with Land Iguana with which shares a common ancestor. Locally very common but classified vulnerable.

WAVED ALBATROSS *Phoebastria irrorata*

The only albatross located in the tropics, this soaring seabird

weighs up to 4 kg and has a wingspan of up to 2.5 m. Found mostly on Española. Will forage hundreds of kilometres from its nest. Classified critically endangered.

SHORT-EARED OWL *Asio flammeus galapagoensis*

Wingspan of 1.0 m, weight c. 3 kg. Darker and smaller than mainland species. Hunts animals and sometimes birds as large as boobies by night and, unusually, by day, to meet the challenge for prey of the Galápagos Hawk.

GALÁPAGOS FINCHES *Geospiza, Camarynchus, Platyspiza, Certhidea, Pinaroloxias*

Small Galápagos birds are hard to identify. I am less confident now of the annotations on these drawings, but the finches, with bill forms and other characteristics varying according to the dominant food type on the individual islands, were very important for Darwin's insight into natural selection. The birds are related to the tanagers and are not true finches.

LAVA

The archipelago is volcanically active (eruptions in 2008, 2009, 2015 and 2022) and provides unexcelled examples of both A'a and Pahoehoe lava fields, the former jagged, the latter 'ropey'.

RED-FOOTED BOOBY *Sula Sula*

Smallest member of the booby and gannet family. Wingspan c. 1 m, weight 800 g; white and brown morphs exist, the latter predominating in the archipelago. Nests and perches in trees (an unusual habit for a web-footed bird) as well as occasionally on ground; dives for fish and squid.

CHARLES DARWIN RESEARCH STATION

Located in Puerto Ayora, Santa Cruz. Non-profit research and advisory centre run by the Charles Darwin Foundation.

GALÁPAGOS PENGUIN *Spheniscus mendiculus*

Only penguin found north of the Equator, endemic to the Galápagos thanks to cool Humboldt and Cromwell currents. Height up to 50 cm, weight up to 4 kg.

TROPICBIRD *Phaethon aethereus* and related species

Plunge-dives for squid and fish. Wingspan 1 m, length 50 cm plus the same again for the tail streamers, weight c. 700 g.

FLIGHTLESS CORMORANT *Nannopterum harrisi*

Unique Galápagos endemic species, found only on Fernandina and Isabela; the only cormorant that has lost the power of flight. Feeds on fish and other marine creatures up to 200 m from the

shore. One of the world's rarest birds, classified vulnerable. Length 89–100 cm, weight 2.5–5 kg.

NAZCA BOOBY *Sula granti*

Another plunge-diving fish-eater, predating especially the South American Pilchard. The largest booby. Wingspan 1.5–1.8 m, weight up to 2.3 kg.

YELLOW or MANGROVE WARBLER *Setophaga petechia*

Commonly nests in mangroves and manzanillo trees. Insectivore, occasional berries taken. Wingspan 16-22 cm, weight 10 g.

GALÁPAGOS GREAT BLUE HERON *Ardea herodias*

Wingspan up to 2 m, weight up to 3. 6 kg. Normally fishes in shallow waters but, unlike most other herons, can harvest from deeper offshore sources.

GALÁPAGOS HAWK *Buteo galapagoensis*

Top predator in the islands; feeds on insects, iguana hatchlings, gulls eggs and young etc. Hunts in groups, the dominant hawk feeding first on any kill or carrion. Size varies from island to island; wingspan can be up to 1.4 m and weight up to 1.5 kg. Only some 150 breeding pairs exist today.

David Pollock was born in London in 1949. He lives in Charlbury, Oxfordshire. He read Chemistry and Economics at Keele and spent his working life in Whitehall, the City and in the direction of two major trade associations.

On retirement in 2010 he gained a post-graduate certificate in architectural history at Oxford. He also began to paint full time.

Travel, drawing and painting are his lifelong passions. He has filled more than 40 sketchbooks with a record of his journeys in five continents over three decades and, since retirement, has exhibited his strong figurative watercolours in well-received shows in Oxford and London.

David was Chairman of Oxfordshire Artweeks , the UK's biggest and oldest open-studio festival, from 2012 to 2019.

Limited edition giclée prints of the drawings in this book are available. Please enquire from the publisher on info@pallasathene.co.uk

For further information about our books, please visit www.pallasathene.co.uk, or find us on social media:

@Pallasathenebooks @Pallas_Books
@Pallasathenebooks ISSUU @Pallasathene0

First published 2023 by Pallas Athene (Publishers) Ltd,
2 Birch Close, Hargrave Park, London N19 5XD

© Pallas Athene (Publishers) Ltd 2023
Text and images © David Pollock 2023

ISBN 978 1 84368 214 1

Printed by Bissetts Bookbinders

The
Pacific

50 km - v. apprx

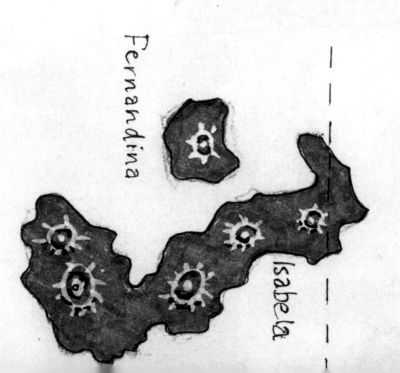

Fernandina

Isabela